MW01537943

To Cheryne.
Best Wishes

Mary

When the Bombs Were Silent

MY LIFE AFTER WAR

By Mary Leach

◆ FriesenPress

One Printers Way
Altona, MB R0G 0B0
Canada

www.friesenpress.com

ISBN
978-1-03-913603-8 (Hardcover)
978-1-03-913602-1 (Paperback)
978-1-03-913604-5 (eBook)

1. BIOGRAPHY & AUTOBIOGRAPHY, PERSONAL MEMOIRS

Distributed to the trade by The Ingram Book Company

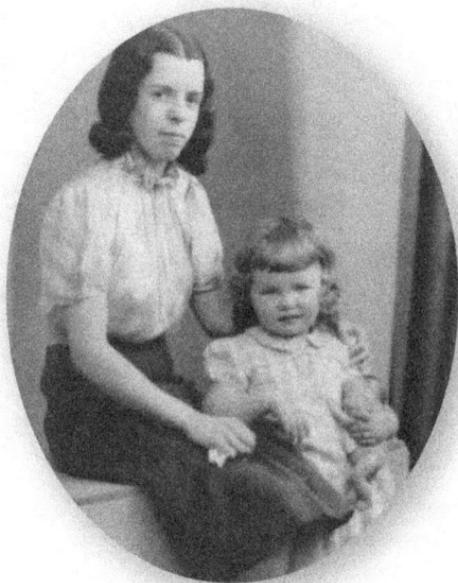

Dedication

My story covers a period of eighty years of my life. A story I never intended to write. But as books depicting the events involving World War 2 became prevalent on book store shelves, I realized that I had my own version of those historic events. During the Editing and Publishing process, my lack of computer knowledge became obvious and I turned to my daughter-in-law Nancy for help. Over the following months she dealt with the more complicated computer instructions involved in the process.

Without her help, this book would not exist, I can't thank her enough. I also appreciate her opinion on the content as an objective reader not directly involved.

My brother Robert deserves a big thank you for his recollections of conversations with our father around his army career. He also passed on to me information and pertinent data gained from living in the area in question. I also want to thank my family and friends who encouraged me to continue when I became unsure of the results.

A special thank you to Emily, Kayla and the staff at Friesen Press for their guidance and support.

Thank you everyone.

Chapter 1

Some people say that a child just two and a half years old has no recollection of events surrounding them. That was my age on September 3, 1939. The events of that historic day were made known to me in the years that followed from listening to my mother's emotional description. The lives of my family were about to be changed for the next five years.

My parents Isabella and Harold had taken me on a train trip to Southport on the west coast of England. It was the first time I had been to the seaside. As we stood by the railings overlooking the beach, the tide was out, leaving a large, flat stretch of sand filled with people enjoying the sun and sea breeze. Dog owners walked their pets, and children built sand castles or played football. Visitors staying at hotels along the seafront, most of them older couples, sat in rented deck chairs enjoying the view as screeching seagulls flew overhead. In an amusement arcade, Dad threw balls at wooden skittles, winning a large stuffed panda bear that I held in my arms as we walked along the promenade.

We were approaching the long pier where stall holders sold ice cream, lemonade, balloons, and buckets and spades for children to build sand castles on the beach. We were going to join the line for ice cream when suddenly, my father stopped. People all

around us also stood still, listening to a loud voice that seemed to be coming closer. A van with a loudspeaker on the roof was approaching, causing vehicles and horse drawn carriages to move aside to allow the van to pass unhindered. Later, as my mother recalled the events of that day, the message being aired from the van had become clear as it came closer. England and Germany were at war as of eleven a.m. All military personnel were to report to a nearby location for transport to an enlistment centre. Even though war was expected, the hope of a last-minute peace agreement was now lost. The men and women on that sidewalk that day held hands, and they hugged each other and their children. Handing the panda bear to my mum, my father picked me up in his arms, kissed both of us, put me down, and walked away. Those deck chairs on the beach were now empty, the ice cream stalls were closed, the traffic slowly started to move, passing the families standing on the Southport seafront, and as if on cue, a dark cloud covered the sun.

Dad had told mum that he would likely be leaving at short notice, but he had hoped that our outing to take me to the seaside would end in a full day of fun. The return train ride was not like the one we had arrived on earlier that morning. Those happy, laughing children now sat beside their fathers' empty seats. Holding the stuffed panda bear my father had won, I held onto my mum's hand while she tried to explain why he was not coming home with us.

Two days later, my father came home wearing his British Army uniform. From the cap on his head to the shiny boots on his feet, this man was a stranger to me until he removed the cap and picked me up. He was allowed to stay with us for one night before reporting for duty to Harrington Barracks in Formby, north of Liverpool. The next morning, I was not the only child on our street waving as our fathers left, not knowing when we would see them again.

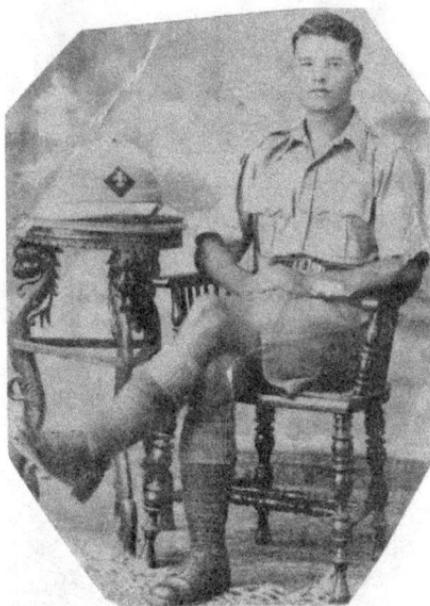

My Dad

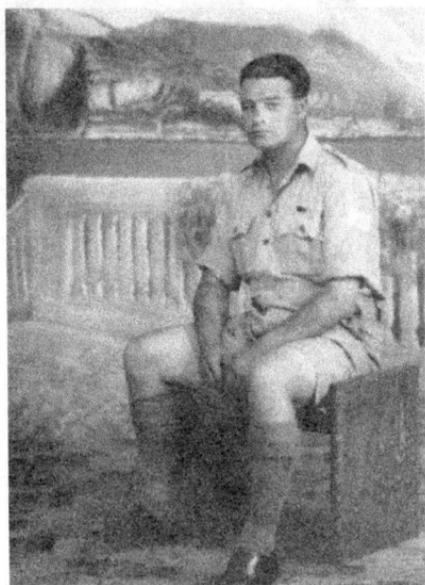

Chapter 2

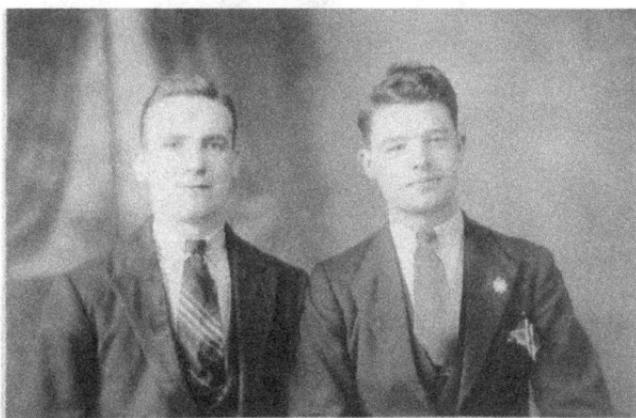

My father and his best friend Jim had enlisted in the army in their late teens, joining the The Kings Own Liverpool Regiment. Prior to returning to Oldham and meeting my mother, he had attained the rank of corporal and when they married in 1936, Jim and his wife Barbara stood with them.

Jim and Barb were now living in Formby, just a couple of streets away from Harrington Barracks and a short distance from the beach, so when they invited mum and me to stay with them, adding that Dad and Jim came over from the barracks most days, mum wrote back accepting the invitation. Travel was still allowed during daylight hours so we took the train to Formby, where we were met by Barb and her father. As soon as we stepped down from the train, I was swept up into Barb's arms, "You look just like

your dad," she said. Her father shook my mother's hand and said, "Welcome! My name is Walter, I feel like I know you, your hubby talks about you all the time," he said. He picked up our cases and led us from the station and into a waiting taxi, the drive to their home taking us by Harrington Barracks where soldiers were drilling, but I did not see my dad.

There had been some enemy plane sightings along the coast and over the Irish Sea, and when darkness fell the searchlights came on, probing the night sky for German aircraft. I remember sitting by the window, fascinated as those bright, shiny fingers of light swept from side-to-side, searching. The next morning, Barb suggested we take Merlin, their pet Boxer, for a walk along the beach. As we walked, she told us how that stretch of coastline was long, wide, and flat, presenting a perfect landing area for the big glider aircraft used to silently carry enemy soldiers. Because of this, the beach had been sectioned off with barbed wire, leaving limited access to the water.

The Port of Liverpool on the river Mersey had long been a major docking area, from the days of square-rigged clipper ships to the present day where ocean liners embarked passengers bound for America, making it a major enemy target.

I had never been this close to the sea. Barb threw a ball into the shallows, Merlin retrieved it, ran back to us, and shook sea water all over us. Trenches had been dug above the high tide line, and it was into one of these that we ran for cover when we heard a plane approaching. Thankfully, it turned out to sea and we were able to return to the house, our coats covered with soggy sand thanks to Merlin's shaking. As if that was not enough, that night the sirens sounded. It was the first time we had heard them, but it was to be the first of many nights to come.

As the wailing sound continued, we hurried into the back garden to the shelter. This type of protection was named an Anderson Shelter: its bottom half was dug below the ground and sheets of corrugated steel formed the curved roof, which was

covered with a thick layer of earth and grass. This was not the first night we would spend underneath what had been their vegetable garden. The space was small enough, but with the addition of my mum and me it was a tight fit. Merlin had his own bed in one corner, where he curled up and was soon asleep.

That same night during the raid, a neighbour who lived a couple of houses away had run back to his house for his wife's medicine and saw a light in the upper window of a house that was supposed to be empty. The following morning when Jim came to check on us, the neighbour reported what he had seen and pointed out the window. Later, we learned that a man spying for the Germans had been arrested. A search of the house revealed a shortwave radio, maps, and information showing the location of the Port of Liverpool on the River Mersey, south of Formby.

Barb and her parents, along with other neighbours, gathered along the street which was filled with military personnel and vehicles. As the news spread, local police set up barriers to keep out anyone who had no right to be there. Questions were asked and answers demanded. How could a spy have been in contact with the enemy just two streets away from a large army barracks?

We had been with Barb and her family for a week when Dad said it was time we went home. The situation was getting worse. One day when a group of children were leaving school, an enemy plane flew low and opened fire, killing some and injuring others. Waiting parents witnessed what happened to their children.

As things continued to worsen, any unnecessary travel was no longer permitted. Store owners crisscrossed their store windows with adhesive tape to prevent shards of flying glass from injuring anyone close by. Piles of sand bags protected the entrances to buildings and mobile first aid stations were set up, ready to help anyone in need of medical attention. A tank stood at the entrance to the barracks, and at the time, I didn't know tanks were something I was going to see more of.

Chapter 3

Walking home from the station, it was obvious our town was preparing for war. A large brick and concrete air raid shelter was being built in the open space behind our row of houses. It was destined to become the place where mum, our neighbours, and I would be spending a great deal of time in the coming years.

Situated in the north west of England, Oldham was an area with a large percentage of mills and factories, some of which would begin to manufacture military supplies. As a result, our town would be marked as an enemy target. The fearful sounds of warlike air raid sirens, enemy aircraft, and bombs falling, did not occur right away, in fact, things were relatively quiet.

A short distance away in Chadderton was The Avro Aircraft Company, where they were building the Lancaster Bomber. The completed sections of the plane were then loaded onto large, flat trailers and driven through the streets to Stockton, where they were assembled, tested, and handed over to the Royal Air Force. Because the trailers were so wide and the streets narrow, some street lights and other obstacles had to be removed. As the plane that would help save our lives passed through the streets, crowds of people cheered as the completed sections drove by.

Blackout rules were in effect, all windows must be covered after dark to prevent any interior light from showing, street lights were turned off, and the buildings on street corners were painted white to avoid people walking into them. All vehicle headlights were half covered with black tape, which made me think they looked like sleepy animals, crawling the street. Ration books that contained weekly coupons for food and clothing were issued to all families.

As the war continued, food became scarce making farm produce strictly controlled. Farmers were told not only what to plant but how much. Private, unused land such as the property attached to large estate homes was requisitioned. People listened to radio broadcasts for news that a convoy of supply ships from North America had safely bypassed the German U-Boats that prowled the North Atlantic. A successful crossing might include an orange or banana for each of us that week. Eggs were precious and a can of real milk was like liquid gold, mostly milk came in powered form. A trip to the local market might turn up a few veggies, but usually potatoes were all you came away with. Two slices of toast with a few chips between was not bad though.

My mum loved to knit, and in the evening while listening to the radio, she would knit socks while I drew pictures until it was time for bed. Lots of women formed groups knitting socks, scarves, and fingerless gloves to be sent to our soldiers during the winter months, using wool that they unravelled from donated sweaters. Any donated clothing was also taken apart and remade into clothing for children. Nothing was discarded that could be refashioned into something useful.

This war was about to become a long period of adjustment and acceptance of a way of life, as well as something that we would have no control over.

Chapter 4

O ur next-door neighbours Mark and Anne Wilson had three children aged two, three, and five named James, Michael, and Julie. My mum and Mrs. Wilson had become friends, so we spent a lot of time together. Mr. Wilson had a medical condition which prevented him from active service, so he became an Air Raid Warden. These men and women walked the streets after dark, knocking on any door where the smallest glimmer of light shone through the curtains. Should the sirens suddenly sound, they also directed anyone out on the streets to the nearest shelter. Searching for survivors after a bombing was the part Mark dreaded most of all. People living in heavily populated areas could not always get to a shelter in time.

The sound of approaching enemy aircraft was becoming a nightly occurrence, usually around nine p.m. The dreaded sound of sirens would begin, warning everyone to go to the shelter. My mother would dress me in my siren suit, a one-piece warm cover-all similar to what children wear in the winter. Mum always had a bag of supplies sitting ready by the door which she would pick up, then take me by the hand, and lead me to the brick and concrete shelter that was being constructed when we had left for Formby.

It was very different from the one in Barb's backyard. While that shelter was covered with a thick layer of earth and grass, this one had a thick concrete roof making it easier to see from above. Each family had its own small area in the shelter, usually containing a couple of camp cots, folding stools, a small table or box with a Primus stove, a lantern, a small shelf for books and games, a kettle, and cups to make tea. Mum's bag of supplies contained powdered milk and some food to last until our next meal. A jug of water and a bucket with a lid tucked into a corner was all the small space could hold. A small opening between each area allowed families to talk to each other, helping to pass the long night. The Wilsons had the space adjoining ours, so one of their children usually slept on one our cots.

Mark stopped by during his rounds to check on us, reporting any enemy bombers searching for the A.V. Roe aircraft factory. When the all clear sounded about five or six in the morning and we were able to leave, there was no guarantee that your home was still standing. The tank we had seen in Formby was not the first, and seeing soldiers carrying guns became a normal sight

Chapter 5

Mum received a letter from Dad saying that he had been promoted to sergeant and was being reassigned. He could not say where he was going of course but as it turned out, it was Gibraltar. The Rock of Gibraltar sits on the south coast of Spain directly across the Mediterranean Sea from North Africa. That stretch of water is the narrowest section of the Mediterranean, which made Gibraltar a strategic British stronghold. Dad later told us about German U-boats entering from the Atlantic Ocean and trying to sneak passed the Rock on their way to Egypt, where the German Army under General Rommel was fighting the Allied forces. Many years later, my husband and I would visit Gibraltar still under British rule. After receiving his letter, Mum took me to a local photographer and had a picture taken with me holding my doll as I stood beside her. She had wanted Dad to have a nice photo of the two of us, her real intention being, "Just in case!"

Chapter 6

Women all over the country were taking over the jobs left by the men who had gone to fight. Both single and married women who had no children filled those positions. Many joined the armed forces in various roles where they drove ambulances, buses, and even trains. They took non-medical positions in hospitals or porters at railway stations. Young women, some still in their teens, who wanted to do their bit for the war effort joined The Women's Land Army living and working on farms, planting vegetables which helped increase the food supply.

They learned how to operate farm equipment, drive tractors, milk cows, feed pigs, and take produce to market. For a young woman from the city, it was a whole new way of life. Some became part of the farm's family and remained close even after the war ended. They truly helped to feed a starving Britain. Many chose factory work that was hard and dirty, their overalls covered with oil and grease at the end of a long shift. As it turned out, my mother was about to join them.

For months before war was declared, the government anticipated the need to protect innocent children in cities that would become bomb targets. Family services inspectors visited farms and villages, interviewing families who might be willing to provide a

safe home for children from the large cities under threat. If they were old enough, the children would be taught to help with easy farm chores. Parents who agreed were required to sign a form giving permission. The first few days of the war saw hundreds of children picked up from their home or school by bus and taken to the railway station. As they waited in groups for the train that would take them to the country, the children (some who had never been out of the city before) held tightly to the hands of their younger siblings.

Leaving their home and family to live with people they didn't know must have been terrifying for those too young to understand why. Holding shopping bags, brown paper parcels tied with string containing their clothes, each child also had a tag pinned to his or her coat collar showing their name and the safe temporary home they were heading to. Some of them clutched a favourite doll or stuffed animal. One last required item hung from every small shoulder, a cardboard box containing a gas mask. It was a cumbersome, rubber thing that covered the head and the entire face. Gas bombs that were dropped from enemy aircraft made the masks necessary in spite of the smell and discomfort.

Chapter 7

My grandparents lived on the outskirts of Oldham where there was little industry, and they had suggested to my mother that I go and live with them. They pointed out that I would have more freedom in an area that was safer compared to our location with its nightly raids. Dad's parents lived in a large house built in the late 1800s, with a stone lion that sat beside the steps leading to the front door. It soon became my favourite place to sit, where I surveyed my imaginary kingdom. There were not many other houses in that area, The Lowes, a large treed expanse of open land leading to The Pennines, the ridge of hills that divided the counties of Lancashire and Yorkshire. A field and some trees separated the house from their closest neighbours, an elderly couple who were taking care of their two grandchildren. Betty and John were both older than I was and used to wandering the open spaces, so they often came across the field to play with me and Parker, my grandparent's Golden Retriever, aptly named for poking his nose into places he shouldn't hence "Nosey Parker."

The house had a large cellar, in the centre of which stood the air raid shelter named a Morrison Shelter. It consisted of two large slabs of steel separated by four thick steel legs, the open area surrounded by woven metal mesh. The top served as a table, where

my grandparents played board games or did jigsaw puzzles. A mattress on the lower slab provided some comfort during a long raid. This was where Parker and I spent the night snuggled together, the only sound coming from a small radio as Granddad listened to the news broadcasts.

My mum was now working the night shift at a factory, where she made ammunition shell casings. After her twelve-hour shift, her overalls covered in oil, she walked home along empty streets, waiting for whatever was to come. She was working with a group of Irish women who had crossed the Irish Sea looking for jobs to support their families back home. As they got to know each other better, the long hours of hard labour seemed to pass a little faster.

The Germans had built unmanned V-1 flying bombs, which were fired from the European coast and gave off a red glow as they screamed through the night sky. The worst was when the screaming stopped and the bomb fell to the earth below, destroying hundreds of lives. My mum was with us that night when the sirens sounded, urging everyone to take cover. Closing the cellar door behind him, Granddad followed as we hurried down the stairs to the safety of the thick, stone walls. Parker didn't need me to tell him to go into the Morrison shelter, he was already in there waiting for me to join him. My grandparents had both settled down with a book to help pass the long night ahead and mum, who never seemed to get enough sleep, crawled in with Parker and me and was soon asleep.

We did not hear the sound of the approaching rocket but from the explosion that shook the whole house, we knew it had landed close by. Then there was the sound of something falling or crumbling, which turned out to be our tall chimney and a large part of the roof collapsing. Early the next morning, when the all clear sounded and we were able to go outside, no one was prepared for what awaited us.

On its fall from the sky, the flying bomb had torn through the home of Betty and John's grandparents and exploded in a house

across the street. Most of our roof was gone, as were the second-floor windows. We stood there, Granddad with tears in his eyes, his arm around grandmother as she stood shaking, realizing that the field between our house and our neighbours had saved our lives. Mum held my hand just as she had on the train that day as we left Southport, Parker whining softly as he stood between us.

We saw crumbled walls and the crater where the remains of the bomb still smouldered, firemen poured water on the smoking ruins while police and army personnel searched for survivors as they dug through the rubble. Betty, John, and their grandparents were killed. We would never know why they had not gone to the shelter. A small body believed to be Betty was found underneath a heavy dresser where it was assumed she had tried to hide.

We continued to live in the bottom half of the house until other accommodation could be found. Undamaged beds were carried down from the second floor for my grandparents, but the mattress down in the cellar was where I shared my blanket with my furry friend. It was about three weeks before another house was found and by then most of the debris had been cleared. The bomb disposal crew came to assure my granddad that the area was now safe and asked that Parker not be allowed near the site.

Chapter 8

We had moved into a home in the middle of a row of attached houses about half the size of the one we had left. There was no bathroom, just an outside toilet inside a tiny structure beside an old tree in the back yard. Sadly, there was no stone lion sitting beside the front door.

Mum continued to work at the factory and on those days that she spent with us, Granddad wanted to know what was happening there and in that area in general. We sat and listened to her talk about the nightly raids and bombings, the walking through the dark streets to and from the factory. She had given most of her food coupons to Anne Wilson, who insisted on her eating with them before going to work which allowed her to sleep a little longer.

A few days later, we were just sitting down to supper when mum arrived. She had the next day off so would be able to spend the night. People didn't have phones then like today, so we didn't know in advance that she was coming. She dropped her bag by the door and picked me up in her arms, as if she hadn't seen me in weeks. Grandma laid an extra place at the table and filled a plate with poached eggs, baked beans, and toast, and then poured her a cup of tea. Not long after, with a clean plate, a second cup of tea, and obviously ready for bed, my granddad asked my mum

how our neighbours, the Wilsons, were coping. Sitting back in her chair, both hands around her tea cup, she began. She had been with Anne and Mark when Mark's brother John knocked on the door. John managed a company in London where they produced hand held radio parts and was in our area on business, so he took the opportunity to visit his brother.

My mum later recalled that after lunch, the conversation had turned to the London blitz. She said that what followed made her parents realize how much easier it was for the cities and towns in the north. John was staring through the window, and she knew he was reliving the things he was telling us, tears running down his cheeks, and he didn't bother to wipe them away. She recalled how he told them about waves of German planes dropping bombs on the most heavily populated areas. The London Docks were hit hard, hundreds of buildings burning and collapsing and not enough fire engines to quell the towering flames. People were seeking shelter anywhere they could find it, under railway arches where the walls were built of stone, or in London's underground railway stations. Hundreds of bunk beds and portable toilets had been provided to give small comfort to those who were sleeping on the train tracks, some with nothing but the clothes they wore.

Of all the cities that were bombed outside of London, Liverpool was heaviest hit. It supported the allied forces in the Atlantic by being Britain's main shipping and receiving port. During the first week of May 1941, for five consecutive nights, the German Luftwaffe dropped their bombs mercilessly on the city. This resulted in the loss of seventy-thousand homes, twelve thousand lives and almost obliterated Liverpool.

Usually on a Saturday if things were quiet, we all went to an outdoor market where stall keepers sold basic items that were still available such as household supplies, tools, books, and sometimes apples and potatoes. Chips, with a little salt and vinegar and wrapped in newspaper, was a nice treat that we enjoyed as

we walked around the rows of canvas covered stalls. An elderly woman who sold used books, games, and jigsaw puzzles would always wave us over to show my grandparents any new stock and take the items they had finished with.

On Sundays, if the weather was nice, we would walk to the park to feed the ducks on the boating lake, the boats having been removed due to the lack of people to take care of them, as well as a shortage of customers. The first time we had gone to the lake, Parker had jumped right in to join the ducks and they had flown away, leaving him all alone and soaking wet. Now Granddad kept him on a lead until we were away from the ducks and something else had caught his attention.

Chapter 9

It was now 1944, and I was seven and what was referred to as a tomboy. Playing with dolls was not my thing, and most of the children on our street were boys anyway. Chasing each other, climbing trees, and getting dirty was a lot more fun. One day, hiding in a tree seemed like a good idea, until I fell out of it. The dirt and stones around the base of the tree scraped the skin and some flesh from my right knee. One of the boys fetched my granddad, who helped me limp to the nearby doctor's office as blood ran down my leg and tears ran down my face. My granddad held my leg still as the doctor removed the pieces of stone, and I screamed. Later, when the doctor sent me home with a big thick bandage and instructions to stay out of trees, I thought it could not possibly get worse, but it did. After a couple of days, my knee was badly swollen and painful. My grandma felt unable to deal with the daily dressing changes and with the need to keep checking on me through the night, she was not getting any sleep, so my mother took a leave from the factory and took me home.

Each morning there were new puss filled sores, and when the doctor came, he said it was time for the hospital. He had diagnosed the infection as impetigo which spread rapidly, and the infection had already gone to my head. The first thing they did

at the hospital was shave my head, and a cage was placed over my legs to relieve the pressure from the bed covers. During the six weeks I was there, other patients were brought into my ward, some having suffered serious injuries from bomb blasts or flying glass. I became aware that feeling sorry for myself at the loss of my hair was nothing compared to the loss of a limb or a serious head wound.

Volunteers worked hard to keep each bed space clean in readiness for the next patient but the sound of an approaching ambulance caused a flurry of activity among both medical and non-medical staff. Windows had been fitted with heavy wooden shutters that were closed when the sirens sounded. Patients who were able to walk were moved to the cellar that had been set up with extra beds. A young porter lifted me into a wheelchair and took me down on those first nights before I was able to walk by myself. He always had a joke, usually something about "When would the jerries stop dropping cotton balls?"

Hours and hours of sitting and watching the constant tireless efforts of the nurses convinced me that was what I wanted to be when I grew up. Mum came to visit me every day and as she sat beside me holding my hand, I told her that I had no right to take up a bed that was needed for a more deserving patient. After going home, the doctor came to see me each week for another month before I could go back to school.

Chapter 10

The government knew they were going to need lots of extra space for training facilities and billets for soldiers who were waiting to be shipped overseas. One of the biggest problems was the shortage of beds for those who required time to recover after surgery from serious injuries. The owners of large country estates were approached and asked to provide rooms in their homes that could be converted into convalescent hospitals. The men and women already taking care of these large estates were ideally placed for the task of organizing non-medical support, as the doctors and nurses were spread very thin countrywide. Volunteers from nearby villages sat with patients and read to them or played cards or board games. Most of the homes had lovely gardens where, in nice weather, the patients could sit outside and enjoy the peace and quiet of the countryside.

We received a letter from my father to say he was now a sergeant major and had been reassigned. It turned out to be Egypt but like the Gibraltar posting, he could not say at the time. He said he had received the photo of mum and me, and it was always with him. In her letters, mum always left space for me to tell Dad what I had been up to and my promise to stay out of trees. Mum listened to the nightly news broadcasts about

how British troops under General Montgomery were doing as they fought against the Germans in Egypt, thankfully, she didn't know that was where Dad was.

Chapter 11

We were now spending fewer nights in the air raid shelter, which was an indication that maybe the war was coming to an end. There were some nights when the sirens didn't sound at all and the chance to sleep in your own bed was like an award for good behaviour.

Food was still in short supply and ration book coupons required as before. Mum had received a note from my school requesting that she go with me the following day, as we children were all to be immunized against measles and diphtheria. Due to poor diet and living conditions brought on by the war, lots of children had contacted measles, causing serious outbreaks in some large cities.

May 8, 1945, VE Day. Victory in Europe had at last been achieved. There was to be a celebration at the town hall, and the Wilson family, mum, and I took a bus to the town centre, which was already crowded with happy, cheering people. The mayor gave a speech about the future in store for Oldham, and how the bombed homes and businesses would be rebuilt. A brass band played songs like "Pack Up Your Troubles" and Vera Lynn's "White Cliffs of Dover." Some people danced with strangers or linked arms as they sang along. When the streetlights came on, for the first time in five years, those of us who were too young to remember, stood looking

at the glow that lit up the buildings around us. When the band played "God Save the King," the whole crowd sang the national anthem and tears flowed as the Union Jack was slowly raised atop the town hall.

On the way home, Mr. and Mrs. Wilson and my mother talked about the changes that were coming. No more air raid sirens or nights spent in the shelter, listening for enemy aircraft and explosions soon to follow. Blackout curtains would no longer be needed, and the tape on store windows could be removed. They also said that Guy Fawkes Night would be allowed, and when I asked what that was, Mr. Wilson said, "We will have a very big fire" with a big smile, and then refused to say any more about it.

Chapter 12

E very day we expected my dad to walk through the door and as each day passed, it seemed longer than the last one. It was three weeks later when he finally arrived, this time wearing not a uniform but a gray suit with a collar and tie. Not a word was spoken as he held us close in his arms, tears running down mum's face as she laughed and cried at the same time. It took a few days to believe he would be there each morning when I woke up and as the days passed, he told us of the months he had spent on Gibraltar and how much he enjoyed learning the history of the Rock itself. During off duty hours, he had spent time in a small cemetery where some of the crew from Lord Nelson's ship Victory were buried following the battle of Trafalgar in 1805. When the topic turned to Egypt, I had my own questions like, "Had he ever ridden a camel?" and "Was the desert really very hot?" His answer to both was, "Yes," but he informed me that camels didn't smell very nice, and he did not recommend I try it.

There were four other families on our street whose fathers came home, sadly however, two other dads didn't make it. One had been killed on Normandy beach, while the other, a member of the Royal Navy, had died when his ship was torpedoed in the Atlantic Ocean.

The landlord of the local pub wanted to welcome the heroes home in style. He invited the men and their families for a neighbourhood reunion. Beer, wine, meat pies, and potato chips were served to the grownups; pop, ice cream, and cake for the children. Handshakes and speeches were the order of the evening along with singing, laughter, and no shortage of tears. Later, when the pub's local customers arrived to offer a handshake or a pat on the back, we young ones were taken home and put to bed.

We had gone to visit dad's parents, who he had not seen since before that historic day when war was declared in 1939. They had once owned a small business, where his mother made hot lunches for nearby factory workers. They dropped off their own dishes on the way to work, and she would then fill them with her home-made beef pie or rice pudding with raisins just in time for lunch. Dad was delighted when grandma placed a large pie on the table, saying how many times he had thought about her pie as he ate the basic meals served in the mess.

After lunch, Dad said he wanted to see what was left of the old house where he had grown up. The roof and second floor had been torn down, leaving only the heavy stonework around the windows. The first floor was still standing, as was the front door with the lion still on guard. Mum had not told Dad about the V-1 flying bomb until after he came home, knowing he would worry about us. Now as he stood with his father, looking at the ruins and the area where the bomb had landed, he was made aware of how close we had come to being killed.

The Germans later developed the V-2 rocket, which had a longer range and more explosive power. Fortunately, the war ended before the new missile was used extensively.

Chapter 13

After the war, things started to improve. Food was not yet plentiful, however, more ships were arriving daily from North America, Australia, and New Zealand. Factories began returning to their peacetime production of everyday goods such as clothing, furniture, cars, and bicycles.

I had never owned a bike, so Dad decided it was time I did, and he took me shopping. The one we chose had a basket on the front and a bell on the handlebars, but there were no training wheels. He said I was going to do it the right way, and that it wasn't like falling out of a tree. He started teaching me to ride in an empty school yard, and falling off a couple of times and oil on my socks was not sufficient excuses to cancel the whole thing. Following a couple more attempts that produced a few bruises and a missing tooth caused during a collision with the bell on the handlebars, I became a cyclist.

November 5, 1605 was the day that Guy Fawkes and a group of Catholics conspired to blow up the Palace of Westminster and kill King James the First in retaliation for his persecution of Roman Catholics. When it was announced that Fawkes had been arrested, fires were lit all over London to celebrate the king's safety.

Bonfire night had been banned during the war for the same reason there were no street lights or anything that could attract enemy attention. On November 5, 1945 bonfires would burn in every corner of the land, now I knew what Mr. Wilson had been talking about.

The location for the fire was selected by the fathers, who chose an area close to the now empty air raid shelter. A candle in a jar was made by putting a candle in a clean, empty jam jar and making a long handle from braided string. Carrying the lighted jars, the older children went door-to-door asking for donations of anything that would burn, or money towards the cost of refreshments. Our mothers then got together and planned who would bake cake, pies, pots of hash, or a big favourite, mushy green peas that would be enjoyed as we stood around the fire. Warm food, a fire on a cold November night, what could be better. As November fifth grew closer, the pile of wood, old furniture, and tree branches got taller, and a replica of Guy Fawkes was placed on the top. A loud cheer went up as the fire was lit, and people brought chairs and stools and sat as the food was handed out.

The expressions on the faces of the children, me included, who had never seen a bonfire must have been a rare sight. We threw a potato into the embers around the rim of the fire until they were roasted and tasted delicious with a little butter. The bigger the pile, the longer we waited for the flames to reach the top. Eventually, the Guy replica was ashes, the fire died down, and the children had been taken home to bed, leaving the fathers to make sure the fire was out. They would return to clean up the remains the following day.

Chapter 14

We were moving to a new house in an area called Limeside. It was quite a bit bigger than our old one, with a large back yard. Along the front, a low wall with a gate separated the house from the street. On moving day, we said goodbye to the Wilsons and their children. Anne and Mark had always been there to offer support when mum needed it, and mum and Anne had become close friends.

Our new home was on the outer edge of a large estate, part of a rebuilding project. The windows on the front of the house looked out across fields and farmland so that after darkness fell, all we could see were the stars. After living where open spaces were limited, riding my bike on those country lanes with my new friends was the best part of the day. Looking across the fields reminded me of the one beside my grandparents' house and the fun Betty, John, Parker, and I had playing there.

On June 13, 1949, my brother Robert was born. There had been some complications with the birth that required surgery, delaying my mum and the baby from coming home. But when the taxi pulled up at the gate, I ran out to help mum as Dad carried his new son into our home. It soon became obvious that mum was not getting better, the area where she had undergone surgery

had become infected with peritonitis, and she was sent back to the hospital. However, because my brother had been released, he could not be readmitted. This presented a problem for my father, since we had moved away from family and friends who would have been happy to help him care for baby Robert.

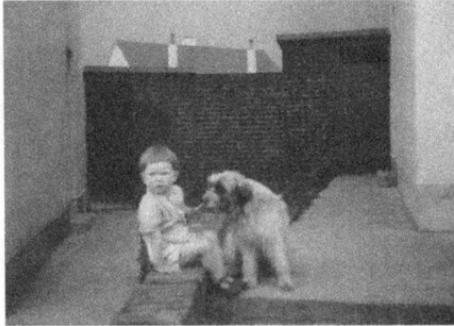

The war years had taught me some basic household chores as I helped both my mum and grandma around the house. Sweeping, dusting, basic cooking, washing dishes, and laundry would now be useful. My father's job involved long hours, and we were grateful to a neighbour who was a friend of mum's, who took care of my brother until I came home from school. My grandmother came a couple of days per week but since we had moved, we were much further away from them than before. The trip required two buses each way, and it soon became clear that it was just too much for her. We needed a solution, and we needed it fast.

I had never imagined that I would be caring for a baby at the age of twelve, but I was about to find out. Before school was scheduled to reopen following the Christmas holidays, Dad had gone to the Board of Education and informed them of his situation. Mum's prognosis included a lengthy recovery and with this information, my father was given permission for me to stay home for a period of up to one year. During the following months, required school work was delivered by a student who lived in the area.

Robert and me

Chapter 15

Mum came home three months later, much thinner than her normal, slim physique. She was going to need plenty of bed rest and regular visits by a nurse. Weeks became months as she slowly regained her health and was able to help take care of my brother. I had tried my best to do what was needed, daily feedings, bathing him, and taking him for walks in his high wheeled pram soon became routine. Even on rainy days we still went for our walk, Robert snuggled under the waterproof hood and apron of the Silver Cross pram, and me zipped in my hooded raincoat. As time passed, my childcare abilities improved although I never got used to those middle of the night feedings.

My dad and I somehow muddled through. On the weekends, he would take care of heavier jobs such as window cleaning, vacuuming, or mum's vegetable garden. Dad also did the grocery shopping and cooking. I took care of our meals during the week, making sandwiches, boiling eggs, and opening cans of soup, which was the extent of my culinary ability. Fortunately, there was a fish and chip shop not far away.

Ten months later, I returned to school. I still helped around the house and spent time with Robert as he started to walk and explore his surroundings. If the weather was warm enough, we

took our lunch and sat on the brick wall in front of the house. Our neighbours' dog Monty would join us and sit politely waiting for Robert to share his lunch. After the last crumb had been eaten, Monty put his nose to Robert's forehead, which always made my brother giggle.

The following two years were uneventful. Due to the ten months I had been away from school, I was unable to sit the eleven-plus exam (a passing mark would have allowed me to attend grammar school), so I became a student in the secondary modern system. The half-hour bus ride each way made the day longer but I liked school, my favourite subjects were math and geography, and a position on the school net-ball team added to the whole experience.

At the end of those two years, I was fifteen and finished school. I was hired by a cotton spinning company to work in the carding room, where the thick cotton was spun into a thinner strand. My job was to take samples, noting the time and the machine number, then take them to the lab for testing. I developed a cough after four months, the result of breathing in the dust, which was a constant part of the carding process. It turned out to be a good thing because what I was about to learn, would provide me with employment for years to come.

Mum and Dad

Chapter 16

My new job was with a large bakery that made slabs of fruit cake, which were placed in tins and shipped to customers throughout Britain. My job involved sealing the cartons and attaching a shipping label. The bakery was not far from home, just a short walk along a country lane, allowed me to go home for lunch.

They moved me into the office after a few weeks, where I sorted and filed customer accounts. My favourite subject in school had always been mathematics and my ability in dealing with numbers had been noticed, so my boss made me an assistant in the accounts payable office.

The bakery had a wedding cake department where tiers of fruit cake were decorated to celebrate not just weddings, but also birthdays and retirements. When time would allow, I stood behind a glass divider and watched as two women created their icing art form, and noticing how much time I spent watching them work, they offered to teach me the basics of cake decorating. Instead of going home, I started taking my lunch with me and ate at my desk while I worked, which gave me a little free time before it was time to go home.

I was given a white apron and cap and a round fruit cake was placed on a turntable in front of me, the first step I was told was always to cover the cake with a layer of marzipan as a base for the icing. A few years later in Canada, I lost a job because of my insistence that a cake could not be iced without first applying a smooth base, which only showed my lack of knowledge on the subject.

The field opposite our house had become a football pitch where every Saturday afternoon local supporters, including my dad, got together to watch a game of soccer. Mum was having trouble making space for a new shelf unit, and she asked me to go and ask Dad if he would come and help. Crossing the street, I found my dad talking to a tall young man who was a member of the local team, unable to play because of a shoulder injury. They were both cheering, and I interrupted them. "This is Jack," Dad said, grinning at me as he walked away. "Why don't you keep him company?"

As we talked, Jack told me he had not been able to play or go to work for a month, but he hoped to be back on the team soon. He said his hanging around the house was driving his mum crazy, and he was spending most afternoons at the movies, and then having a pint or two in the pub with his best friend Andy after dinner. "What do you do for fun?" he asked. I told him about my best friend Pat, who lived in Oldham not far from a dance hall with a really good dance band, where we went on Saturday nights. "How do you get home, the buses will have stopped running by then?" he asked. "I spend the night at Pat's house and get a bus home on Sunday morning, still half asleep," I told him. Jack said that he hadn't been dancing in a while and how about he and Andy meet us later that night and that his friend was a nice easygoing lad.

They met us outside the hall that night just in time to find a table in a corner, where we sat with a drink. Soon Pat and Andy were up on the dance floor doing a quickstep but because of his injury, Jack and I stayed with the slower dances. It was after midnight when we walked Pat home, and it was obvious Andy was

smitten. When he rejoined us where we waited a few paces down the street, he had a touch of lipstick on his mouth. They had made a date for the next evening. Since the three of us lived close to each other, I walked home with an escort on either side. Andy was on the same soccer team as Jack so a lot of the conversation was about that afternoon's game, which Andy felt they would have won if Jack had not been sidelined. When the topic turned to Pat, Andy wanted to know all about her and where should he take her on their first date, and when he left us at the corner of his street, he was whistling one of the songs they had danced to. When we came to my house, we sat on the wall by the gate and there, Jack Leach, my future husband, asked me for a date.

Jack was serving an apprenticeship in sheet metal which included evening classes twice per week, and some nights I would meet him after his class for the walk home. He lived with his parents, Wilfred and Mary Jane, just two streets away which was very convenient, and so our parents became used to us meeting at each other's homes. His mum spent hours feeding the birds that came daily to her back garden. She told me about a small green budgie she had during the war and how whenever the sirens sounded, the bird hopped along its perch, sat under a hanging bell, and chirped repeatedly, "Hitler's a sod."

Jack's shoulder injury healed so he returned to work, and he was back on the soccer team, so Saturday afternoons were spoken for. Pat came over, we watched the game if the weather was decent, and then after dinner, we met the guys for a movie or a dance. Car racing was Jack and Andy's favourite sport next to soccer, and it soon became mine. Over the next weeks and months when there were no games scheduled, we followed the races that featured Stirling Moss, the English driver, as he competed against drivers from around the world.

I specifically remember a race that put us on an overnight bus ride to Silverstone in the county of Northamptonshire. We stood

in the rain as the cars raced around the track. Moss was driving an Austin Healey that day and he won his race, so getting soaked was worth it. Watching drivers like Mike Hawthorne and Juan Fangio driving cars with names like Ferrari, Jaguar, BRM, and Mercedes Benz had been well worth the long ride and the rain.

Chapter 17

Jack's older sister Irene had married and immigrated to Canada in 1951. In her letters to her family, she repeatedly tried to talk her younger brother into following her across the Atlantic. She described the area where they lived on the shores of one of the five Great Lakes, which I recalled from maps in my geography class. She and her husband Sean, who had served in the Royal Air Force, had a two-year-old son David. I knew Jack wanted to join Irene and her family when his apprenticeship was completed.

The night he asked me to marry him and move to Canada was in the summer of 1954, and I was now seventeen. It had never entered my head that I would ever leave England, much less my family given the close ties the war had wrapped around us. But Jack and I loved each other, and I knew he really wanted to go. After all these years though, I still feel that had I said I didn't want to leave England, he would have stayed.

Mum and Dad agreed that it was an opportunity for a new life. England was still suffering the aftermath of the war, and some items were still in short supply. My dad said that although the war years had made me more mature than my age dictated, he insisted that we get married before we left England. Jack's mum had recently returned from a two-month trip to see Irene and her

family, and she came round to our house to tell us what Canada was like. She talked about how the people lived, the kind of food they ate, and something called a bar-be-cue. She smiled as she told us she had stood looking down over Niagara Falls, about an hour-and-a-half drive from Hamilton where Irene and Sean lived, and about the man next door who was actually building his own house. Her description gave us an idea of what our new life on the other side of the Atlantic might be like, and we prepared a list beginning with our wedding and the requirements for our emigration.

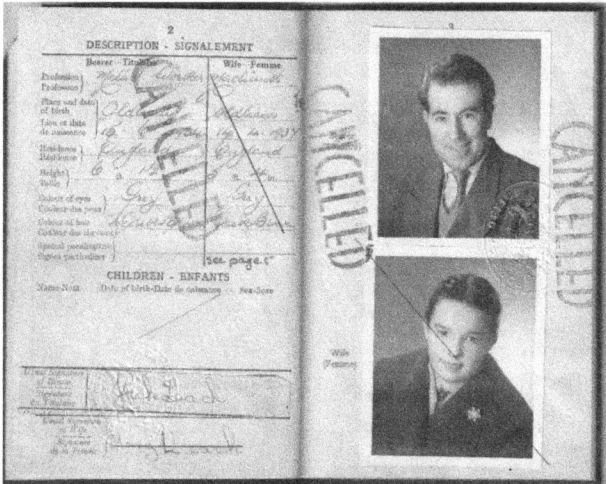

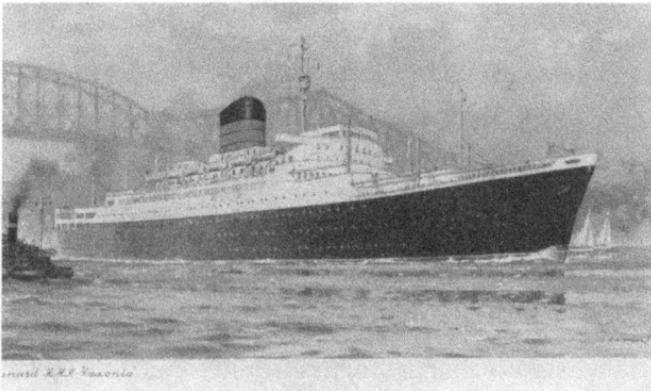

Chapter 18

We had booked passage on the Saxonia, due to sail from Liverpool to Montreal, Canada on November 26, 1954. Our small church wedding was set for the day before we left, after which we were to be driven to a hotel in Liverpool, where we would spend our wedding night. However, things would not be quite so easy. Because the St. Lawrence River into Montreal would be frozen, our destination port had changed, and we would be sailing to New York. Now we needed a U.S. visa and the closest U.S. Consulate was in Liverpool, where we would also be fingerprinted, the reason for this was American security. Taking an early train had been the smart thing to do and after a four-hour wait, holding our visas with ink-stained fingers, we returned home. As we walked through the front door, we found another problem awaiting us; since I was only seventeen, I needed to be added to Jack's passport. And of course, this required yet another trip to Liverpool to have the change approved and the new document issued. This only gave us four days if we were to leave on schedule. As a result of all this, the church was cancelled, and we were married at nine a.m. on Monday, November 22, 1954 at the town hall office of the registrar with Pat and Andy as our witnesses. Taking yet another train back to Liverpool, this time with

our friends for company and a river view lunch, we were on our way home with a passport in Jack's name that showed both our pictures and personal details.

Our wedding night and the next two nights were spent in the back bedroom of my new in law's house. Jack's Scottish Terrier Sandy was not happy giving up his spot for me and kept scratching at the door, wanting to be let in.

Robert was now five years old and a very quiet little boy, and I was really going to miss him. I had been helping him with his reading and had tried to explain to him about Canada, but he didn't seem to understand that I was going so far away. The day we left, I kissed him and said I would see him soon, having no idea when that might actually be. There had been times during those months following his birth that I felt like a real mum when I held him close. As he grew older, we still spent hours sitting together while I read him children's stories or took him for walks.

Once we were both adults I would find that in spite of the thousands of miles between us, we would have a close friendship and a shared keen interest in books, music and aviation. In fact he volunteered with Manchester Airport Security in support of the police and MI5.

Chapter 19

R MS Saxonia weighed twenty-one thousand tons, and it had been built for Canadian service when the conditions in Britain following the war led to people wanting the chance for a better life in Canada. There were a number of ships like Saxonia whose names ended with the letters 'ia' and according to a Cunard employee, there was The Queen Mary and The Queen Elizabeth but no Queen Victoria, so the Cunard Line had given a number of their ships a name ending in 'ia' in Queen Victoria's honour. It just so happened that one of those ships, SS Athenia, had been sunk by a German U-boat at seven-thirty p.m. on September third, 1939 just eight hours after war had been declared.

Looking up at the ship as we went aboard was like entering a tall building and once inside, any fears we had of crossing the ocean disappeared. We were shown to our cabin by a young steward who left us after asking if we preferred the first or second sitting for dinner.

Our small cabin contained two bunk beds, a small table, two chairs, a tiny bathroom, and a narrow cupboard containing extra blankets and pillows. After unpacking, we explored the ship, walking along narrow passages that opened into open spaces for recreation, reading, or just lounging. There was also a shopping

arcade, theatre, and even a swimming pool, which thinking back, shouldn't have been surprising given the size of the ship.

We set sail from the Liverpool docks at about seven p.m. that evening. Entering the dining room for dinner, we were shown to our assigned table with space for six people. The room was huge, hung with chandeliers, decorated with plants and works of art, each table covered with white linen cloths and napkins, and crystal and china embossed with the name RMS Saxonia. There was another young couple already seated at the table, and as the meal progressed, we learned they were going to a place called Halifax, where they would help a close friend operate a small hotel near the Bay of Fundy.

After dinner, we returned to our cabin for our coats and went out on deck. We were now out of the River Mersey and into the Irish Sea, where the ship was to pick up more passengers at Cobe on the south coast of Ireland. The ship had begun to roll as the sea became rough, making it necessary to bring the extra passengers out to the ship on a tender. As soon as the last piece of luggage was stowed, the captain pointed Saxonia's bows toward the Atlantic Ocean and Canada.

Later in the lounge while we danced to the music of a trio, the movement of the deck under our feet had increased as we sailed into the storm. Climbing into our bunk beds that night, we had no idea we were heading into Hurricane Hazel. Both Jack and I, along with most of the other passengers became sea sick, and we were relying on the ship's doctor for medication and advice. No one was allowed on deck, as the waves were washing over the rails and the whole ship shuddered as it nosed down into the deep troughs, feeling as though we were heading for the ocean floor.

Sailing across the Atlantic Ocean normally took six days; however, it was December fifth when we finally docked in Halifax, Nova Scotia. Due to the length of the crossing caused by the hurricane and the passenger's fear that we might not make it to dry

land, we were allowed to go ashore without customs clearance. The feeling of solid ground under our feet reassured us of our safety after experiencing those days of constant turbulence. Later, we signed our names to a sheet thanking the captain for his concern for our well-being during the journey. It was already dark, and the temperature was colder than anything we had never experienced before, and it soon found its way through our clothing that was totally inadequate for a Canadian winter. My father had taken me to his tailor, who made me a navy-blue suit that I was wearing underneath a long wool coat, and I still shook with the cold. We soon returned to the warmth of the ship, and our steward offered to bring dinner to the cabin since we had only been to the dining room the night we left Liverpool.

Chapter 20

On the morning of December 6, 1954, we sailed into New York Harbor to a special welcome. The Saxonia had not entered an American port before, so she received the maiden voyage treatment. We were escorted to the dock by fire boats with their hoses spraying, followed by other boats of all sizes tooting their horns. A band on the end of the pier welcomed us loudly as the harbour master officially shook the captain's hand.

Our cabin steward had given me the biggest red apple I had ever seen as we said good-bye to him, and I put it in my purse until I could enjoy it later. I never did get to eat it because the inspector who checked our luggage confiscated it, because fruit was not allowed through customs. All those movies and pictures we had seen about New York City were right here in front of us, but with all those changes to our arrangements and the frightening ocean crossing, we had not taken time to realize we were actually going to see it, and it took our breath away. We had stood on deck with other passengers as The Saxonia sailed by Ellis Island and the Statue of Liberty and while we waited to disembark, the skyscrapers towering over everything made we new arrivals seem insignificant.

We had taken a cab to the bus station where we would take a bus to the Canadian border, driving through streets thronged with people going about their business. It was amazing to see that volume of vehicles, taxi cabs, police cars, and trucks of all shapes and sizes, hooting at one another to get out of the way. After waiting in the terminal for hours, we finally boarded a bus for the overnight trip to Buffalo. After leaving New York City, the journey was along highways through open country and even though we had never seen roadways like these back in England, we were soon lulled to sleep until the driver stopped so his passengers could get a drink or relieve themselves.

We arrived in Buffalo about six a.m. and then sat in that bus station until nine, when another bus took us over the border into Canada and onto Hamilton, Ontario, where we were met by Irene, Sean, and little David.

And so our new lives began. Jack's sister and her family made us very welcome in their home that was situated near farmland, which made me think of England and little Robert, sitting on the wall with Monty. When Jack embraced his sister, more than just a few tears were shed, but they were soon to be wiped away.

Chapter 21

We stayed with Irene and Sean until the spring, getting used to our new way of life. Jack had found employment in the steel industry thanks to Sean's brother-in-law Jim who worked at Stelco, a large steel making company situated on the Hamilton waterfront. Jack's five-year apprenticeship in sheet metal and the good word from Jim got him the job. In 1980, now a non-unionized member of staff, Jack attended a course in Ann Arbor, Michigan to study computerized methods for cutting steel, which was then incorporated into Stelco's Fabricating Department. He continued to work in that field until his retirement in 1993.

Meanwhile, the immigration department sent me for an interview in the cake decorating department at a large bakery and as I mentioned earlier, it was short lived due to my lack of skill. I began working at the cosmetics counter at the local Woolworth's store, a job that required little concentration and I was soon bored with it.

One day over lunch while talking to another sales clerk, I said that I would really prefer some kind of job where I would be using math. She told me her mother was working at a large china shop just along the street, and she had told her they were looking for someone to help prepare the paperwork for the increasing number of American customers who wanted their purchases shipped over

the border. After giving two-week's notice at Woolworth's and a six-week trial period at the china shop, I was hired. The woman I worked with dealt with the customer, obtaining shipping information, then I would calculate the amount of the sale and after the weight, shipping charges, and customs fees had been added, I took the paperwork to the Canada customs office for approval. The rest of the time I worked on the store's three sales floors, learning about the English china dinnerware business.

My grandmother had taken great pride in her china, allowing no one but herself to wash it following the few times we used it, but I had never really taken much notice. Now I was surrounded by beautiful designs from leading English companies such as Royal Doulton, Royal Worcester, and Paragon. A complete dinner service for eight people could easily cost as much as five hundred dollars, making it a purchase for the more affluent customer. We also sold Doulton figurines including horses and dogs that looked so delicate but in truth, they were just the opposite. Over the time that I worked there, I purchased my own dinner service, finally coming to understand how my grandmother felt about her Royal Albert set.

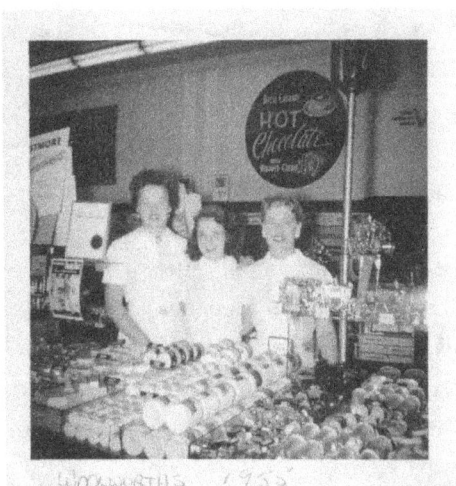

WOOLWORTHS 1955

Chapter 22

We found a small apartment in the city, which made it easier for both of us to get to work using city buses. While living with Irene and Sean during the winter months, the closest bus was a good fifteen minutes away, and through intense cold and snow like we had never known before. The owner of the china store insisted that his ladies wear a hat and absolutely no trousers, but since he didn't usually arrive until about ten o'clock, we all wore a skirt over our pants and had plenty of time to remove them before he arrived. Jack had not had a driver's licence in England, although he had driven the company truck on company property, but he was going to need a Canadian licence if he was going to buy a car. In 1955, obtaining a licence was a simple procedure compared to today, and an appointment just needed to be made at a local garage. Sean drove him, handed the car over to Jack, a member of the garage staff joined him in the front seat, and away they went. After twice around the block Jack had his licence and a big grin on his face. His first car was a used, black MG two-seater sports car. Every weekend we explored the towns and cities around Hamilton. After the narrow winding roads back home, these long, straight highways were like total freedom.

The cities of Toronto and Niagara Falls were about the same distance from Hamilton, and either one could be reached in just over an hour. Our love of car racing continued in our new country, and there were two race courses that we visited: Mosport, north of Bowmanville, and further away in New York State, Watkins Glen, which was in its early stages of becoming known in racing circles. Now, located at the southern end of Seneca Lake, it is a major venue with large entertainment facilities.

It was not long before I felt ready to learn to drive. Teaching me to drive the five-gear stick shift was a learning curve for both of us, as Jack was a patient teacher, but I was a stubborn student. When I became pregnant and the MG had to go, we replaced it with a Chevrolet sedan, which would better accommodate our growing family.

Michael Stirling arrived on schedule, August 3, 1956. Back then, after the birth your stay in the hospital was much longer than it is today, and it was a week before we went home and Jack was able to hold his son. My thoughts returned to baby Robert and how similar the circumstances around the two infants were. I had left my job at the china store and settled into that same routine of feeding, bathing, laundry, and wheeling a baby buggy.

Chapter 22

Michael was four when I took him to England to meet his grandparents. The ship we sailed on was the RMS Ascania, sister ship to the Saxonia. Unlike the frightful experience of my first crossing, Ascania sailed across the Atlantic Ocean on water as calm as a mill pond. We had two chairs assigned to us on the after deck, where we sat following an early dinner, listening to the ship's band. The movie theatre showed children's films in the afternoon, and there were shops that catered to the young passengers.

The huge Royal Liver Building welcomed our ship back to the Port of Liverpool (was it really six years since we had left it behind?). My dad was waiting as we went ashore, and he had tears in his eyes as he hugged us both. He told Michael he was very pleased to meet him, and he admired the trouser suit and small fedora hat that he was wearing. I sat in the back seat on the drive home so Michael could sit next to his granddad. By the time we arrived and saw my mother and brother waiting for us, any thoughts I might have had about him being shy or hesitant were gone. There were two things there that a four-year old boy could not resist—my dad owned a motorcycle with a sidecar attached, and Robert had two pet rabbits called Ricky and Rocky that he kept in a hutch in the back yard.

Jack's small Scotch Terrier Sandy had been killed when it ran in front of a car and his parents had not wanted another dog, but one day on his way home from his job as a company gardener, Wilfred had rescued two young pups from a sack thrown in a garbage bin. The smaller one had died but they had cared for the other, and Toby was now a healthy, playful family pet. Mary Jane loved birds and as well as feeding a magpie that flew onto the window sill every morning, she had a small budgie whose cage door remained open, allowing him to fly around the house.

My mother and brother visited them often, and Robert kept a box of small toy cars there to keep him occupied while the grown-ups chatted. Now the two boys sat on the rug, the cars spread out around them, Toby watching every move as the little bird flitted from one bent head to the other. Mum and I were about to go to the same market where all those years ago we had exchanged our used books and games and walked around eating chips wrapped in newspaper, and Dad was going to watch the boys. Before we left, my dad asked me to dress Michael in the suit and hat he had worn when we arrived, because he was going to take him to meet the neighbours wearing his Canadian style clothes.

My dad's father had died in 1957, but his mother was still living in the same house with the outside toilet and the tree in the back yard. Annie was in her mid-sixties now and no longer making meat pies, but the day she met her great grandson she made egg sandwiches and Bakewell tarts for lunch, and she bought each of the boys a book to help keep them occupied. She had always been an avid reader and all those years ago on those nights spent down in the cellar, there had been books on many subjects. Annie would tell me time and time again that "Books have the power to take you to far off places." She would be happy to know that I too am an avid reader.

Chapter 23

I had told Mum and Dad that I would like to go to Southport, as I didn't want to regret it if I didn't get the chance again. Dad liked the idea, saying it had been a long time since he had seen his friend Jim and his wife Barbara, who still lived in Formby near the barracks, where the two of them had been stationed at the start of the war.

We arrived in Southport in the early afternoon and checked into a small hotel just one street away from the seafront. Southport had certainly changed over the past twenty-one years, more hotels, shops, and lots more traffic. The beach though was still the same, wide and flat, and the tide far out. During the four days we stayed there, we walked along the pier eating ice cream as Dad showed my brother the spot where he had left Mum and me on that day in 1939. We rented deck chairs, enjoying the sun while Robert and Michael rode on donkeys.

The night before we were due to leave, Jim, Barb, and their teenage daughter Jenny met us for dinner. Jenny wanted to know all about that morning on the beach and our dive into the trench, not really doubting her mother's version but also wanting mine. Jim now owned a carpentry business and Barb's mum and dad had moved into a riverfront apartment, leaving the house to their

daughter. Harrington Barracks still stood as a reminder of the way things had been back then, but the hole that had been the Anderson air raid shelter had been filled in and was now once again a vegetable garden.

I could not leave without spending some time with Pat and Andy, who were both married but not to each other. Andy was now the manager of an auto repair shop, and he had married Jean, a school teacher; they had two sons, who were both soccer players. Pat, now a dental assistant, was the wife of John, who was in banking and unfortunately, they had not been able to have children.

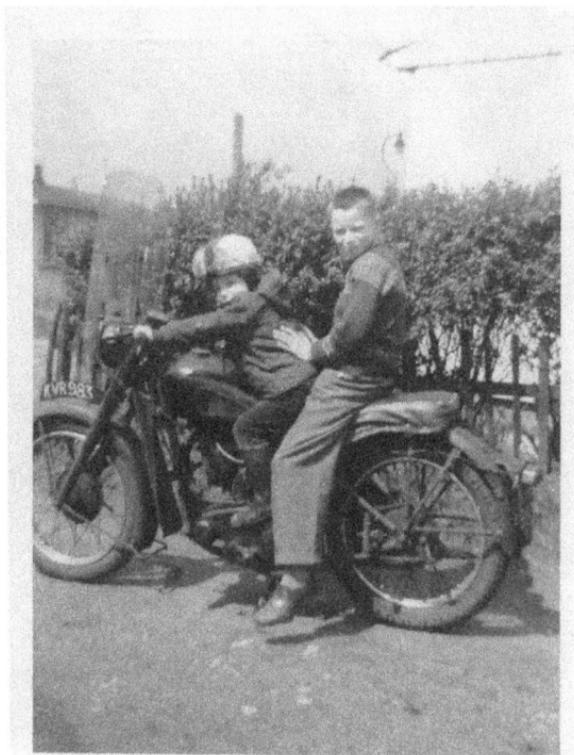

Michael and Robert

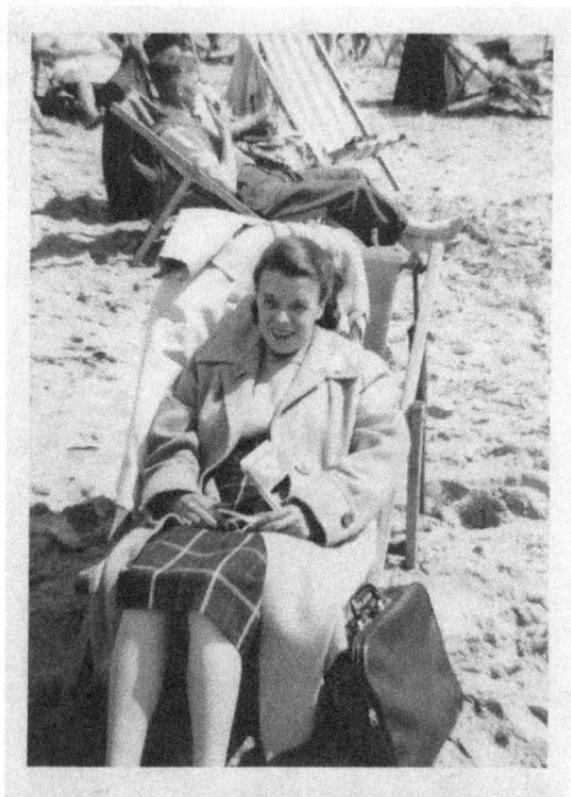

Mum at Southport

Chapter 24

Before we knew it, it was time to leave and return home to Canada, where Jack was awaiting us. The weather was starting to get chilly, and I had made the decision to return home by air rather than by sea and chance a rough crossing. I had never flown before, and I was looking forward to the experience. Mum, Dad, and Robert drove us to the airport in Manchester, where the boarding process was quite uncomplicated. Back then, it was just a simple check of your tickets and luggage, and then you were off. Michael didn't want to leave, and he cried when it came time to say goodbye until Robert promised to send him pictures of Ricky and Rocky. It had started to rain, making the BOAC Bristol Britannia aircraft shine under the airport lights as we walked up the boarding ramp.

We had been served dinner and drinks, the dishes cleared away, when a stewardess came and asked Michael if he would like to visit the captain in the cockpit. It was a special treat for the only young boy on the plane and as she took his hand and led him along the aisle, his eyes were like two saucers. He was returned to me about twenty minutes later, clutching a small box containing a lapel pin of the Bristol Britannia.

Around the time we should have been preparing for sleep, the aircraft's flight level became uneven, and the seat belt light came on. The plane shuddered and suddenly dropped, and I didn't know what to expect, as this was my first flight. The captain announced that we could expect the turbulence to continue for some time, and he would try to get above the storm. There came a huge flash of lightning, and passengers were pointing to the engine on the opposite side from where we were sitting. The whole wing and the engine were covered in a blue glow that was causing panic until the captain provided an explanation. The blue glow was St. Elmo's Fire which was caused by electrical storms that generate atmospheric fields around things like ship masts and airplane propellers. Michael sat in the seat close to the window, staring out at the pouring rain and bolts of lightning flash across the sky. My thoughts turned back to that earlier horrific Atlantic crossing, and I vowed this would be my last. Of course, over the coming years there would be many more, and as of this writing I have crossed seventeen times.

First built in 1952, the BOAC Bristol Britannia turbo prop aircraft was intended for Commonwealth service but as jet propelled aircraft took over Atlantic routes, the Bristol Britannia was retired in 1975.

Just as the weather had delayed our arrival on board Saxonia in 1954, our flight from Manchester to Toronto was about to suffer a similar fate. The pilot announced that due to bad weather, the airport in Toronto was closed, and we would be landing at Pierre Trudeau Airport in Montreal, where we would wait until Toronto reopened. I bought a child's story book and read a few pages to my son as we sat looking out over the runway but after the excitement on the plane, he soon fell asleep with his head in my lap. I was awakened by a hand on my shoulder, a BOAC employee sat beside me and apologised for the disruption we were experiencing. The Toronto airport was still closed, so BOAC had made arrangements

for an extra carriage to be added to the train that ran daily between Montreal and Toronto. Relatives and friends who had been waiting to greet the passengers from the flight had been notified of the change in the time of our arrival. We were driven by bus to the railroad station, boarded the train along with our luggage, and were handed a voucher for whatever the dining car had to offer. About five hours later, we arrived at Toronto's Union Station, and there was Jack. On the drive home to Hamilton, Michael told his dad all about riding in his granddad's sidecar and playing with Ricky and Rocky. He was fast asleep when Jack carried him into our home and put him to bed.

Chapter 25

Michael started school in September 1961, so we moved to a larger apartment close to his school. I walked him there and back for a couple of weeks until he made friends with a boy who lived up the street, whose mother made sure they arrived safely. Jack worked the three to eleven shift, so he was at home to make lunch. And so, when the china store called to say that the woman I had worked with earlier had left and her job was available if I wanted it, I took it. The customer base had changed in the time I had been away, most of our customers had been older people with money to spare or visitors to the area who had seen our ads, but now we were attracting younger customers, buying a few pieces at a time to build their own bone china dinner service.

The owner of the store was a courteous gentleman who appreciated his employees and treated us with respect. He arrived each morning about ten o'clock and before going to his office, he would pass the time of day and enquire about our families. As England was five hours ahead of Canada and overseas phone calls were not as simple as they are today, he placed the calls necessary to order shipments of china months in advance, based on the designs that were most popular. This done, usually by three p.m., he gave a "Good day ladies," and he was gone.

The ownership of the store changed suddenly just before Christmas 1962. The boss we all admired had died, and the business was sold. Our work environment changed almost immediately, no more employee appreciation, no more friendly chats, we were there to sell china, nothing more. This group of women who enjoyed their jobs now found themselves working in a stagnant atmosphere.

By the following August, Jack and I were expecting our second child. Morning sickness and the negative atmosphere at the store was the perfect combination of reasons to hand in my resignation. Our daughter Lauri Sue, arrived on March 14, 1964. Her entry into the world was not as smooth as her brother's had been but following many hours of labour, she loudly announced her arrival. Jack's parents came for a visit in time for Lauri's christening later that summer.

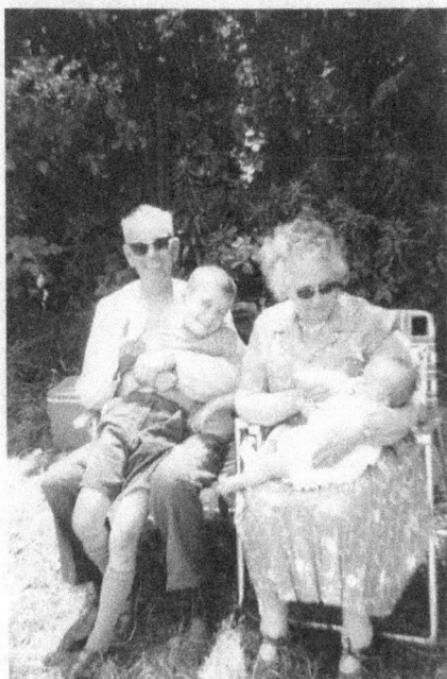

Irene and Sean now had three children, David, Sandra, and Colin, and with Michael and Lauri, their grandparents were enjoying lots of attention. Sadly, four weeks into their visit, Wilfred suffered a stroke, and he died after three days in hospital. On the day that Jack's mum and dad were scheduled to fly home together, Mary Jane boarded the plane alone, carrying her husband's ashes. She would later scatter them in the spot where they had spent many hours listening to birdsongs.

Jack and his sister wanted their mother to come and live in Canada, where she could be with her family. They prepared the necessary Canada Customs paperwork to sponsor her, and the process began. Selling her home in England and saying goodbye to relatives and lifelong friends was hard, but the prospect of spending the rest of her life with her family was more important to her. She arrived as an official Canadian immigrant in 1966, living alternate years with each of our families for the rest of her life.

Chapter 26

T he ensuing years saw our children attend school, become involved in sports and various programs and activities, and forge lifetime friendships. After high school, Lauri attended college and Michael followed in his father's footsteps and enrolled in the apprentice program at the now even larger Steel Company of Canada plant. He continued to work there for twenty-eight years and retired as a licensed Welder and Iron Worker in 2005.

Chapter 27

My parents came to Canada for a visit in 1969. It was the first time my mother had left England, or flown in a plane. I had hoped my brother would be with them, but he was studying hard to enter college. He had also met Lyn, who my mum said was a lovely young woman; obviously Robert thought so too, because they were married in 1971. My little brother's hard work paid off in later years, and he achieved a number of letters after his name in the fields of management and computers. Not knowing it at the time, but the coming years would provide many opportunities for Robert and I to get together.

Dad said he wanted to see the five Great Lakes, not realizing the distances involved. Since Lake Ontario was right on our doorstep and Lake Erie just an hour's drive away, trips to Niagara and Toronto were enough to provide his friends back home with hours of chatter at their local pub. I knew one of the reasons for their visit was to spend time with their grandchildren. Michael was thirteen and Lauri six, and there was no telling when they would see them again. Dad said our decision to emigrate to Canada had been the right one, but he wished there were not so many miles between us. Soon it was time to say goodbye and as they headed

through customs to board their plane, I never dreamt that was the last time I would see my mother alive.

Jack and I were planning to become Canadian citizens, so I had allowed my British passport to expire. When late one night in early February 1972, a telegram arrived to say that my mother was not expected to live much longer, I had a big problem. I needed to be there with her to say goodbye, and fortunately there was a passport loophole.

I boarded a flight to Manchester later the following day, arriving about six thirty the next morning. My brother was there to meet me, and the tears in his eyes were enough to tell me I was too late. I stayed with Dad, spending a lot of time talking about the years we had been apart. Mum had been sick for a while but didn't want to worry me, thinking she would soon be well again, and they would be able to come back to Canada.

I spent a lot of time with Robert, Lyn, and their beautiful little boy Michael during the two weeks I was there. Mum was right. Lyn was a lovely young woman. She made me welcome in their home and over the years, we have become close friends. That passport loophole had permitted me to leave Canada due to extenuating circumstances, but it needed to be renewed in order for me to return home. Just as history is doomed to repeat itself, I found myself in Liverpool once again at that same 1954 location. Sitting in a cafe by the river until it was time to pick up the document.

Chapter 28

In August 1974, Michael was eighteen and Lauri ten. Jack and I were now Canadian citizens like our children and had been issued new passports, and when we decided to go to Spain, Jack's mum said she would gladly take care of Lauri and keep an eye on Mike while we were away. We enjoyed everything we saw, the local people we met, the food we enjoyed, and particularly the history. The amazing Alhambra Palace in Granada where Queen Isabella and King Ferdinand gave Christopher Columbus their support for his search for the Orient that led to the discovery of America was especially interesting. In Seville, the largest Gothic cathedral in the world, surrounded by a Muslim mosque had to be seen to be believed. Evenings spent watching Flamenco dancing and listening to Spanish guitar music made our trip complete. All these experiences made us start planning our next trip to Spain before we even arrived home.

In the summer of 1976, Robert and his family came to see us. Young Michael was now five and had a little sister Jenny, who was just two years old. Driving them back from the airport in Toronto, my nephew was a little disappointed that our car was not the same as his favourite TV character "Kojak," however, there would be lots to take his mind off it like Niagara Falls, a full day of viewing the

whirlpool, taking pictures beside the Horseshoe Falls, and waiting for the lights to come on. They got to know our close friends Tom and Joan, as we got together for barbecues and picnics. As always happens, the days passed quickly, the time with my brother was never long enough, but there would be other occasions for us to be together.

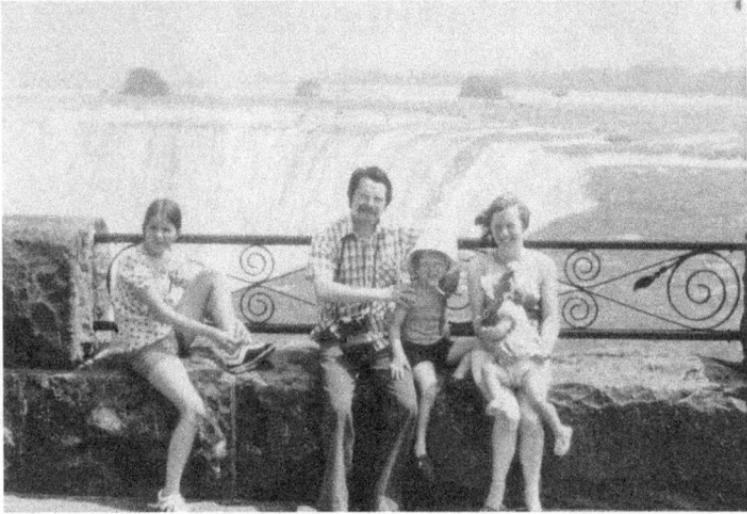

Robert's family and Lauri

Chapter 29

We returned to southern Spain the following year. Gibraltar had been on my list of places to see since listening to my dad talk about the time he had been posted there during the war. However, getting there was not that easy in 1977. The problem was that even though the Rock of Gibraltar was attached to the coast of Spain, it was under British rule and could only be entered by air or sea. Nevertheless, we were determined to see the places my dad had described. Our flight across the Mediterranean Sea was about to top that 1960 flight across the Atlantic in the Bristol Britannia Turbo Prop. With only a few passenger seats, we boarded a Fokker Try Motor, the fuselage made of corrugated metal. With only three other passengers and three crew members, the flight was not nearly long enough.

We landed in Tangier on the north coast of Morocco and from there, we went back across the Mediterranean courtesy of B.O.A.C., landing on the runway that during the war many planes had overshot, only to fall into the sea. In those days, Gibraltar spanned an area about half a mile wide and little than more than one mile in length. For three days, we walked around the areas my father had told me about. The huge St. Michael's Cave in the centre of the rock itself where musical concerts were held, and the small

cemetery where the crew from Horatio Nelson's ship Victory at the Battle of Trafalgar were buried. In the town, the pubs sold fish and chips, the phone booths and mail boxes were red, and the police wore pointed helmets. Best of all were the old gun emplacements, where dad and his men had their guns and binoculars trained across that narrow stretch of water. I wonder what he would think of the bridge that spans the Strait of Gibraltar today.

We spent two days in Morocco visiting the city of Rabat, where the Royal Family had a summer residence. Jack was a pipe smoker and while wandering around the Kasbah, his leather tobacco pouch was removed from his back pocket. Whoever took it must have been disappointed to discover its contents.

Instead of flying back to Spain, we sailed across the sea, enjoying a three-course lunch and the accompaniment of an accomplished guitarist. The ride to our hotel was aboard a local bus filled with local people and their chickens.

Chapter 30

I was now working for a company that manufactured industrial marking devices in charge of accounts payable. On my first day there, I was befriended by a workmate named Kay, who has remained my close friend to this day. There are other friends from those days that I still stay in touch with like Deborah and her family, who have spent time with Robert and Lyn in their home. My boss Yoshio also became a close friend over the twenty years I worked with him. Our childhoods had both been traumatic in ways children are not supposed to experience. That friendship continued until Yoshio passed away in 2018.

In 1942, the year America entered the war, Yoshio's Japanese family had been forcibly relocated from their home in an area near Canada's Pacific coast. Their farms, homes, and livestock were confiscated even though a large percentage held Canadian citizenship, or they were born here and didn't even speak Japanese, and they were all relocated. Yoshio and his father were sent to a different location than his mother and sister, and did not see them again until 1949. He told me how they lived in wooden huts that slept six and only had a small stove for warmth, and when winter came, they placed lighted lanterns under their beds for extra heat. When they were released, Yoshio and his family, along with many more

families, left the west coast, settling in other provinces, where they tried to start a new life. Many of them were dead when the Canadian government apologised in 1988.

Chapter 31

On November 22, 1979, Jack and I celebrated our silver wedding anniversary in Hawaii on the island of Kauai. That evening at dinner, in what had once been the Royal Hunting Lodge of Queen Liliuokalani, my husband gave me my engagement ring, which was made all the more special by those surroundings and my not expecting it. We also visited the islands of Oahu, Hawaii, and Maui, each one offering something different from volcanoes to lush gardens and cultural events. Friends had told us that going to a luau on the beach was a must. The breeze from the ocean blew gently as we watched the ceremony, and the fire-roasted meat was lifted from its oven of leaves and sand. Beautiful young women in grass skirts danced for our entertainment as we ate the meat, lomi lomi salmon, and poi. Before coming home, we visited Pearl Harbor and as we stood at the USS Arizona Memorial, I felt to some degree how the Canadian and American people had felt with regard to the Japanese people living in North America. What had happened to Yoshio's family, their forced separation, as well as their property and belongings being confiscated was a view from the other side of the coin.

Chapter 32

Michael and his fiancée Nancy were married in August 1982. Her parents, Margaret and Donald also had three sons, Robert, Paul, and Eric, and they all welcomed Michael into their family just as we welcomed Nancy into ours. Thirty-nine years later, we are a large family group of twenty as we celebrate birthdays, weddings, and any excuse for a get together. Now approaching forty years together, they enjoy an affectionate and well-grounded marriage.

Michael and his dad became golfers and in early spring before the local courses opened for the season, they and a couple of friends headed down to South Carolina. They would spend a week preparing for the upcoming golf season while sampling the southern hospitality.

Chapter 33

We began spending our vacations in South Carolina at a hotel on the beach near where the guys stayed in the spring. From our balcony, we watched couples get married on the rocks at the edge of the water, and people riding their horses along the beach as the sun set. Lauri was with us on one trip, the drive down taking about two days, with plenty of interesting stops along the way. It was September 13, 1984 when Hurricane Diane hit, the first major hurricane since Hazel in 1954. When the hotel manager called to say everyone was to leave the hotel and beach area, we were directed to a local high school. Attempting to leave the area was futile, as the roads were bumper to bumper with people trying to get out of the area, and every hotel or motel for miles was filled to capacity.

At the school, the organization was almost military in its precision, and we were assigned a specific area on the floor in one of the hallways, away from any windows. A member of the State Hurricane Patrol asked each of us for the contact information of our next of kin, and any medical conditions we had. After a night of sleeping safely on the floor with a pillow and a single blanket, Lauri was the one who slept. Conversation with the people next to

us was about how we found out about that other hurricane in 1954. We could not believe what we were hearing, it was like déjà vu.

We were served a breakfast of juice, toast, and eggs. At about eleven o'clock, a pink total calm surrounded us, we were in the eye of the hurricane. The storm continued until evening when it headed out to sea, and then we were allowed to return to our hotel which had not been damaged, although there were reports of serious damage to many homes and businesses along the coast.

I was taking golf lessons, and my friend Yoshio introduced me to one of the professionals at the golf club where he was a member. Jack had bought me a set of clubs and with the pro's help, I felt ready to try the smaller courses. There was a nice little course close to our beach hotel in Myrtle Beach, South Carolina, and right next to it was a small airfield. It was hard to concentrate on golf when planes were landing and taking off mere yards away. When someone mentioned that there was a glider school at the airfield it was all I needed to hear.

I had no idea what to expect. After flights in engine driven aircraft, it was like the world was suddenly soundless. A cable threaded through a slit in the nose of the glider was attached to a small plane, which towed us to an altitude where the early afternoon thermals took over. When the young pilot sitting behind me said I could release the tow, I pulled the handle, the cable snaked away, and we were on our own with no engine. If you have ever watched a large bird with its wings outstretched, unmoving, slowly flying in circles, that is what it is like. We spent a lot of time down south over the next few years, and a glider flight was always a must for me. Jack did not share my love of aircraft, and that small engineless plane caused him to shake his head and head to the clubhouse. It was usually the same young pilot who took me up, his name was Peter, and his father owned the school. He had been flying gliders since he was twelve, and he knew the answers to all my questions. When I first started calling for a flight, he always suggested a time

between one and four p.m., as apparently the thermals or updrafts are strongest then. What I learned over the many times Peter took me up in the sky was that sunlight warms the earth, which in turn warms the air. The air then rises as a thermal which enables the glider to stay aloft, and a moderate breeze can align the updrafts into rows, allowing the pilot to stay aloft much longer. Between the hours of one and four, thermals can be two to three miles deep. When Peter said, "Ok Mary, release the tow," well, you just have to experience it to know the feeling.

Chapter 34

My father passed away in 1986. I had already booked a flight for July of that same year. It had been ten years since I had seen Robert, Lyn, and their children, and I was really looking forward to my trip. My brother insisted that he take care of dad's funeral and that I stay with my planned trip. Both my parents had died and I had not been there, leaving a responsibility that should have been mine as the oldest child, on the shoulders of my younger brother. When you leave your family to move to another country, you don't think about what happens when there is a death. It wasn't until I had children of my own that I thought about how I would feel if one of them moved that far away, and how my mother must have felt. In spite of the atmosphere of sadness, we enjoyed our family reunion. We drove through some of those quaint English villages, stopping to enjoy a delicious pub lunch. I had never been to London so when Lyn suggested Robert and I go, we took an express train that had us there in less than four hours. In two days, we crammed in sites like the Tower of London, a boat ride on the Thames, a play at The Old Vic Theatre, and Robert took my picture standing by the gates of Buckingham Palace.

Chapter 35

I n the late eighties, our family had settled into a regular, some-
what predictable rhythm. We continued to go to work each
day, socializing with our friends on the weekends. When Lauri
left college, she was hired by the gym where she was a member.
Originally a temporary position, it became permanent, and she
loved it. I now had my own car and after owning a number of
makes and sizes of cars, Jack bought a truck. A trailer soon fol-
lowed and vacations became road trips, camping in some of
Canada's beautiful provincial parks.

On a month-long visit to the East Coast, we arrived in the city
of Halifax, where on that bitterly cold night in December 1954, we
had first set foot on Canadian soil. In New Brunswick, we camped
near the Bay of Fundy, home to the world's highest tides reach-
ing between twelve and sixteen metres. We then drove across the
Canso Causeway to Cape Breton Island. We found a nice camp-
ground in Baddeck and leaving the trailer, we drove The Cabot
Trail, named after the explorer John Cabot in 1497. The trail winds
along breathtaking coastal and mountain views for 298 kilome-
tres, through small fishing villages, offering plenty of opportuni-
ties to stop and enjoy refreshment. Next on our list was a ferry
boat ride to Prince Edward Island and the city of Charlottetown,

where Canada's Confederation Treaty was signed. Confederation Bridge now joins New Brunswick and Prince Edward Island, and at eight miles long, it is the world's longest bridge that spans ice covered water.

Jack and me

In 1982, the company I worked for was taken over by a large American corporation with branches throughout the States. We were moved to a new location on a busy highway twenty kilometres to the east. Travel arrangements for salespeople and visiting U.S. personnel was added to my accounting responsibilities, and the stress of rush hour driving created additional problems for me. Yoshio, also under the pressure that was created by more stringent

rules, told me he was thinking of retiring, and a couple of months later in December 1990, he left. On the advice of my doctor, I followed him in February 1991.

Company award

Yoshio and me

Jack had retired from the steel company in 1993 after thirty seven years in their employ. We planned to take the trailer across the country to Vancouver and the Yukon, and we also wanted to take a trip to Hong Kong before Britain handed it over to China in 1997.

Chapter 36

Robert and Lyn came to spend their twenty-fifth wedding anniversary with us in the summer of 1996. We took relaxing drives around Ontario, enjoying picnics in places like Stratford and Niagara-On-The-Lake, watching outdoor theatre performances. We talked about Jack and I going to visit them in England, it would be the first time Jack had been back since we had left in 1954. However, sadly, none of those trips would happen.

Robert and Lyn 25 years

Following a short illness, my husband of forty-two years passed away in December 1996 and everything had changed. Daily living and chores were no longer shared. From planning meals to vehicle maintenance to shovelling snow to paying bills now fell to me. It was like living in a black hole. Lauri had been living with Jack and me for about a year before he died and I was grateful that she was there to help and support me.

In 1998 Lauri and I went to visit Robert and his family. Prior to our visit Michael, Nancy Lauri and I had planned to move in together into a new house. Lauri and I had decided to move to a smaller place and Mike suggested that instead we share a home together. While we were in England Michael called with the good news that they had sold their house.

So in August 1998, we moved into a beautiful new house with enough open spaces to allow each of us plenty of room to follow our individual interests.

Christmas hugs

Lauri

Chapter 37

September 11, 2001, I was in England visiting my brother. Robert had planned a trip to The Lake District and we had just checked into our rooms at the Black Bull Hotel in Coniston. Turning on the television, we were just in time to see the plane fly into the World Trade Center in New York City. We thought it was a movie until we went down to the bar for a drink and met a young American couple on their honeymoon. The groom, a member of the U.S. military, was expecting to be recalled at any time. We stayed just the one night, the events in New York taking away any thoughts we had of enjoying the beauty of the lakes.

It just so happened that the following day, September 12, 2001, the village of Coniston was holding a special funeral service. Donald Campbell, the only person to set a world speed record on both land and water on the same day in 1964, had died in 1967 when his boat named Bluebird crashed on Coniston Water while he was attempting a new speed record. His body and the remains of his boat were recovered in May 2001. On September 12, 2001, his coffin was taken onboard a wooden tour boat and slowly driven around the perimeter of Coniston Water. His coffin was then carried into St. Andrews Church, which stood on the edge of the lake. Following the service, he was buried in the small

graveyard beside the church. We headed home to my brother's house the next day, a route that took us by Lake Windermere, the one lake I had read and heard about growing up but had never seen. I was not disappointed, as it was just as I had imagined.

I had flown to England on a charter flight and still had two weeks to go. There was no way of knowing what the U.S. government would do or how they would react to the terrorist attacks on September eleventh. I wanted to be with my children so on September fourteenth when transatlantic flights resumed, I called Air Canada. Two days later, having been bumped up to first class, I went home.

Chapter 38

I was now in my sixties and life was less hectic. Lauri and I took a Caribbean cruise in 2003, and I flew to England twice more. Once, in 2005 and the last time was in 2014 for Robert's sixty-fifth birthday party.

Robert and Lyn have come to Canada four times since we all moved in together. Bob and Lyn planned to come for a visit in June 2011. The week before they were scheduled to arrive I was diagnosed with a detached retina and required emergency surgery. It was too late for them to cancel. After the surgery Mike took me home and immediately left to pick them up at the airport. A daily part of their visit involved Bob putting drops in my eye every few hours. He was a vigilant task master. I needed to keep my head down and stay sitting up even when I slept. This also meant that he needed to do all the driving, which he enjoyed.

Robert and Lyn came to Canada in 2017 for my eightieth birthday and we spent a few days in the small town of Cobourg, on Lake Ontario. With accommodations at the water's edge and just a short drive to our favourite restaurant, it was ideal. I remember my brother standing on the end of the pier, gazing across the lake with no land in sight, and his remarks about the size of this country,

and how Jack and I had made the right choice even though he had not understood it when I left him.

The last time I saw them was 2019, Robert was now seventy and not in the best of health. We drove to Toronto and rode the elevator on the outside of the CN Tower, taking it all the way to the top. At 553 metres, it is the tallest freestanding structure in the western hemisphere.

At the end of this visit we spent a few days in Southhampton on the shore of Lake Huron. Michael and Nancy's close friends, David and Lynn, own a cottage there and they invited us to stay for a few days. We took advantage while in the area to visit Tobermory, a resort town on Lake Huron located at the end of the Bruce Trail, which winds its way through some of the most scenic areas of Ontario. It stretches all the way from Niagara Falls to the tip of the Bruce Peninsula. The Bruce Trail Association, a group of hikers and lovers of the great outdoors, maintain its pathways and bridges, while protecting the plants and creatures that live along its length. On the drive back from Tobermory, we all got our first sighting of a black bear.

Chapter 39

With conversations I have had with my own children and other young people about the lessons they learned in school, I have learned that the war years were not accurate in the telling. The actions of our enemies, the lives lost, the displacement of children and the cities and towns that were bombed was information sadly missing in our schools. It is a part of our history that the young need to know. I have attended Remembrance Day Parades for many years that were attended by veterans, active military personnel, older citizens who remembered the war. I assumed that the lack of younger people in attendance was because they didn't know about the sacrifices that were made by the older generation. I thought that they had not learned about this and therefore did not understand the significance. While that may be true for many, I have realized that more are taking an active interest and wanting to learn about the war years.

My daughter-in-law Nancy, a Student Mentoring Educational Assistant with the local board of education, asked me if I would like to volunteer to help students with their reading at the special education school where she worked. The students in the class to which I was assigned were of mixed race, and in the fifteen to sixteen age range.

It just happened to be November eleventh, and the literacy teacher had attached a number of pictures to the white board, each one depicting scenes of the London Blitz, where people spent the night sleeping in underground train stations to avoid the bombs. The word "Blitz" comes from the word blitzkrieg meaning lightning war.

When a student asked about the pictures, she looked at me and said, "Mrs Leach was in England during the war, so why not ask her?" These were teenagers. Why would they want to listen to me? But they did listen as I told them about the nightly attacks, our spending every night in an air raid shelter, and my little friend who had been killed, along with her family, by a flying bomb. They listened to every word I said.

The young are asking their parents and teachers questions about our veterans and the sacrifices they made to protect our country from what was happening in Europe. They are attending the services, wearing poppies, and helping with veteran support groups.

Chapter 40

Hamilton, Ontario is home to The Canadian Warplane Heritage Museum, which has one of the only two Avro Lancaster Bomber Aircraft in the world still flying the other is owned by the British Royal Air Force an aircraft that was such an important part of my early childhood.

My story ends here with an incredible recent event. One I had no idea would ever happen. On July 31, 2021 at one p.m., I boarded Hamilton's Lancaster Bomber for a short flight over Niagara Falls and the city of Toronto. The sky was blue, the Rolls Royce Merlin engines were loud, and I was actually flying in a "Lanc!"

Flight crew and three other passengers

CPSIA information can be obtained
at www.ICGtesting.com
Printed in the USA
BVHW031055090422
633743BV00001B/1

9 781039 136038